My First Five Years

Images by

ANNE GEDDES

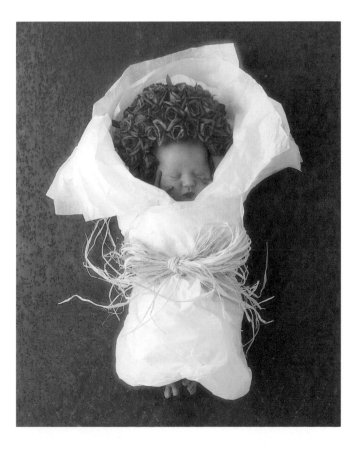

ANNE GEDDES ™

ISBN 1-55912-022-3

© Anne Geddes 1994

Published in 1995 by Cedco Publishing Company,
2955 Kerner Blvd, San Rafael, CA 94901.

First USA edition, January 1995
Second printing, February 1995
Third printing, April 1995
Fourth printing, June 1995
Fifth printing, August 1995
Sixth printing, September 1995
Seventh printing, September 1995
Eighth printing, May 1996
Ninth printing, July 1996
Tenth printing, August 1996
Eleventh printing, September 1996
Twelfth printing, October 1996
Thirteenth printing, November 1996

Designed by Jane Seabrook
Produced by Kel Geddes
Color separations by MH Imaging
Artwork by Bazz 'n' Else
Printed through Colorcraft, Hong Kong

Please write to us for a FREE FULL COLOR catalog of our fine Anne Geddes
calendars and books, Cedco Publishing Company, 2955 Kerner Blvd.,
San Rafael, CA 94901.

ANNE GEDDES

Anne Geddes, an Australian-born photographer, resident in Auckland, New Zealand, has won the hearts of people internationally with her unique and special images of children.

Not only is her work widely recognized and sought after in the commercial field, but her exceptional images have received resounding critical acclaim, attracting a host of professional awards.

Many of Anne's distinctive and memorable photographs have been published internationally, in periodicals including the USA's prestigious *Life* Magazine, Germany's *Tempo*, the *London Sunday Mirror,* and *The News of the World* "Sunday Magazine," to name but a few.

Anne's work mirrors the joy and love found in the children who will form the future of the planet. She says, *"To be able to capture on film the innocence, trust and happiness that is inherent in the next generation is a very special responsibility. It's work that rewards me daily with a great deal of personal satisfaction."*

Another major challenge in Anne's life is to ensure that the photography of children is widely accepted as an art form that legitimately competes with any other form of photographic speciality.

Anne is married to her friend and business partner Kel. Together they have two children.

Contents

My Birth

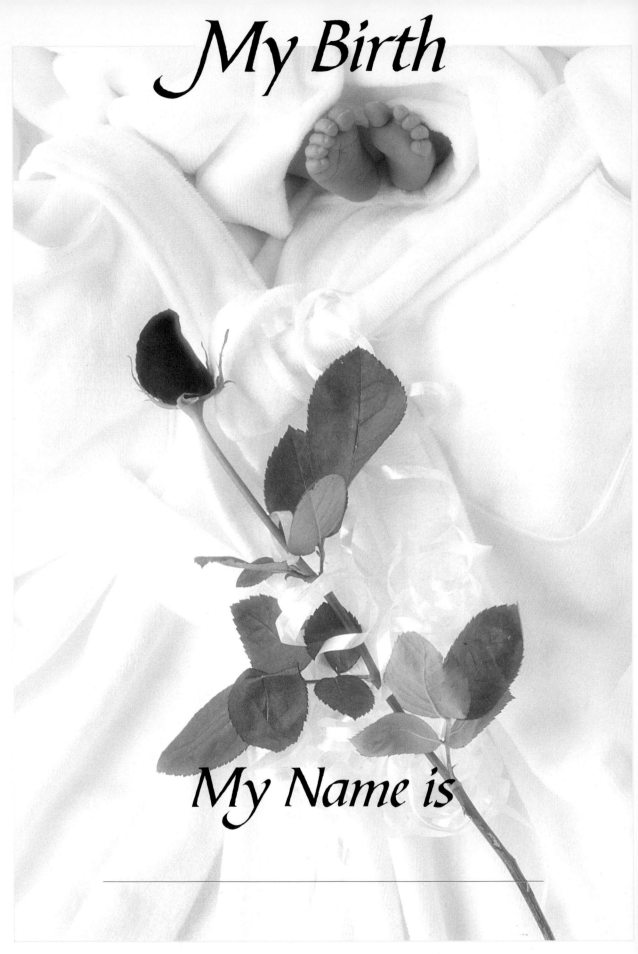

My Name is

I was born on _____

at _____

The time was _____

I was delivered by _____

I weighed _____

and measured

My eyes were _____

My hair was _____

Mementos

My Birth Announcement

A lock of hair

My hospital tag

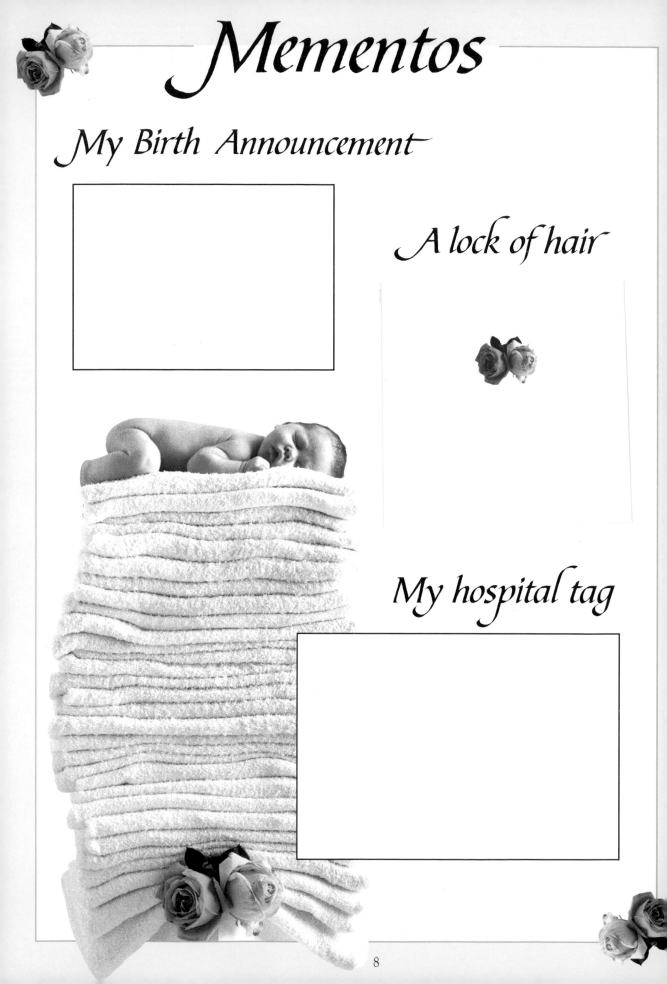

Newspaper Clippings

What was happening in the world

Photographs

Comments

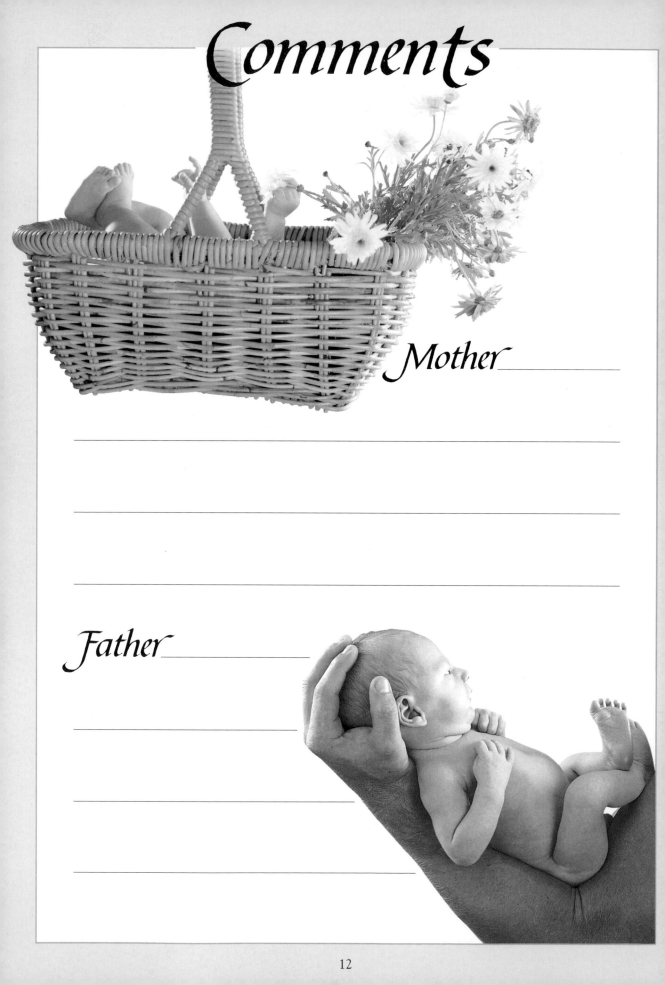

Mother_____

Father_____

12

Special Messages

Family _____

Friends _____

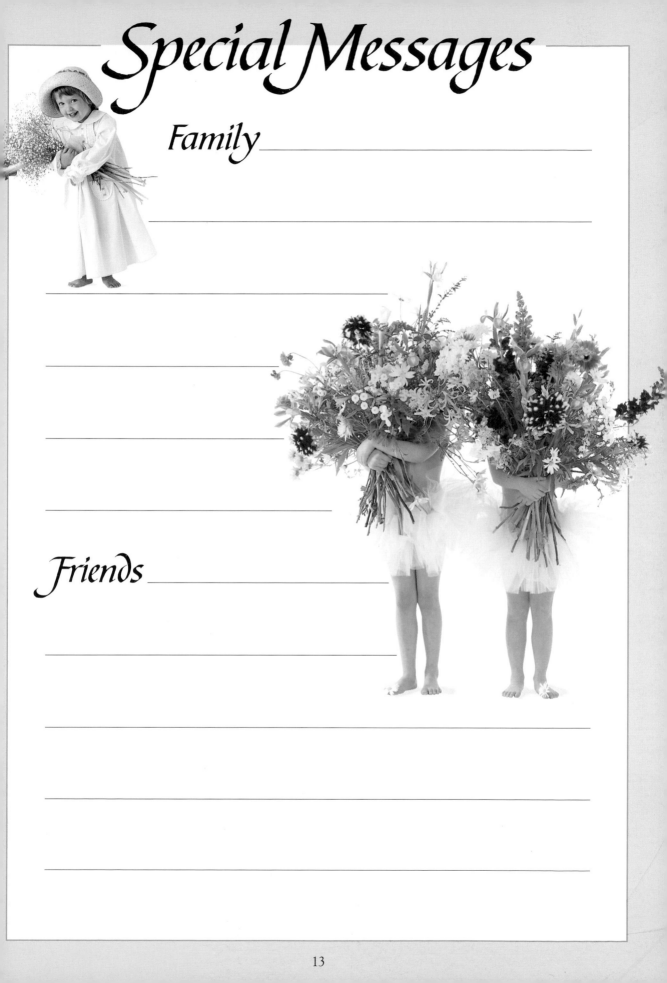

Visitors and Gifts

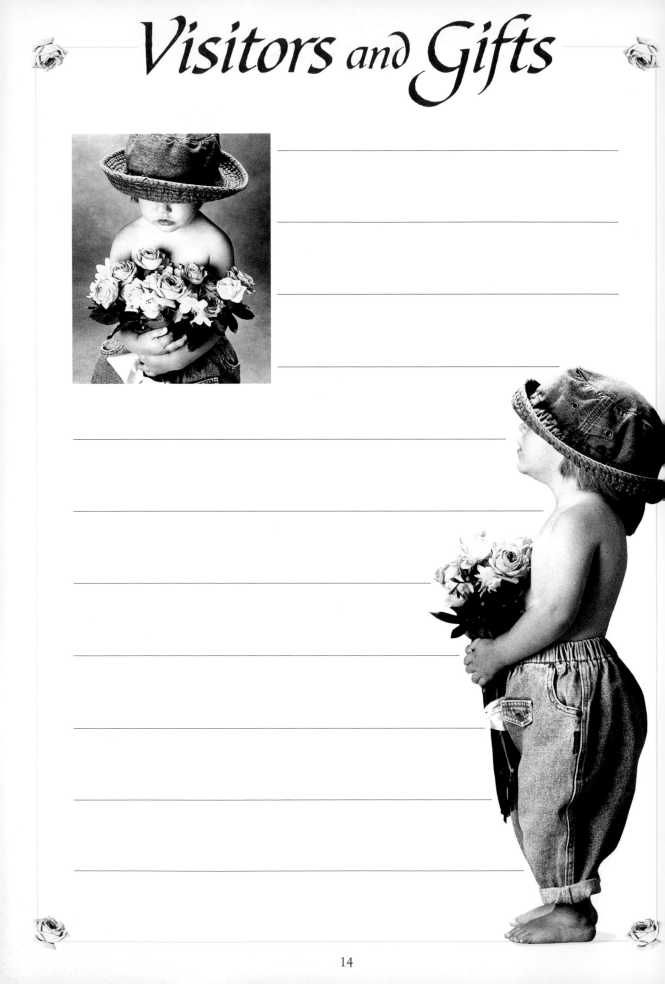

Signs

Star Sign _____

Chinese Year _____

Birth Stone _____

Birth Flower

Naming

My full name is_____

My name was chosen by_____

because _____

My pet names are _____

Ceremonies celebrating my birth _____

Comments_____

Photographs

My Family Tree

Grandfather

(photo)

Grandfather

(photo)

Grandmother

(photo)

Grandmother

(photo)

Mother

(photo)

Father

(photo)

Baby

(photo)

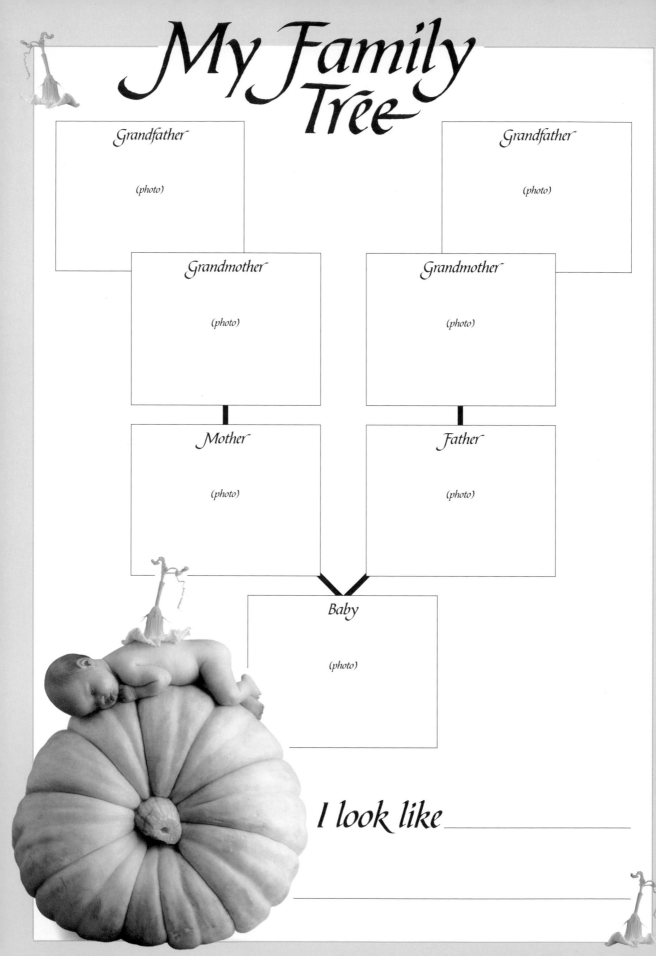

I look like _____

Photographs

Brothers and Sisters

Three Months

Weight _____

Length _____

Comments

Photographs

Six Months

Weight _____ Length _____

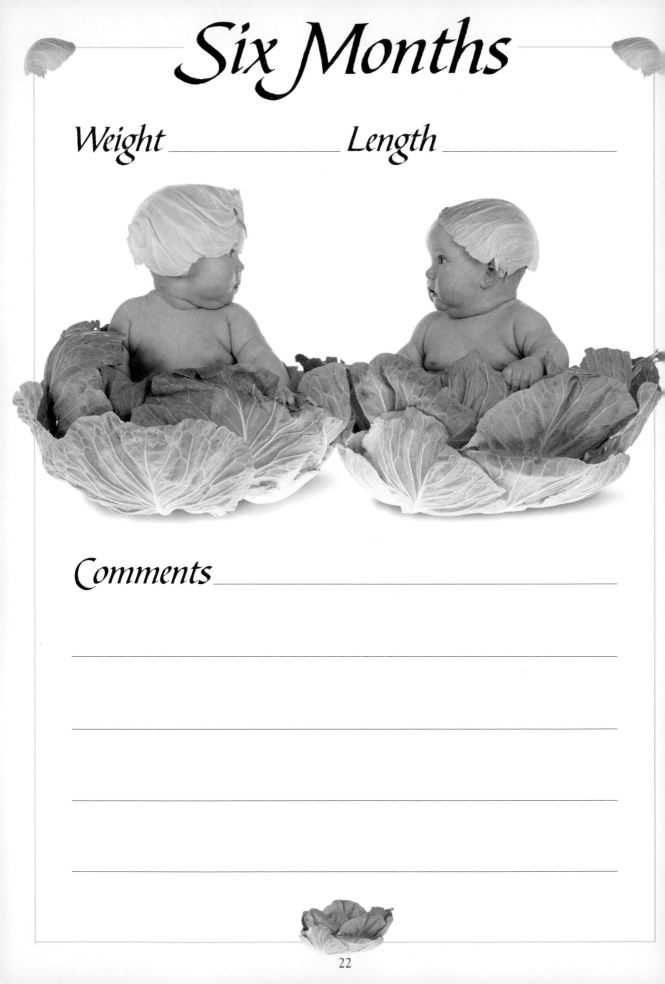

Comments _____

Photographs

Nine Months

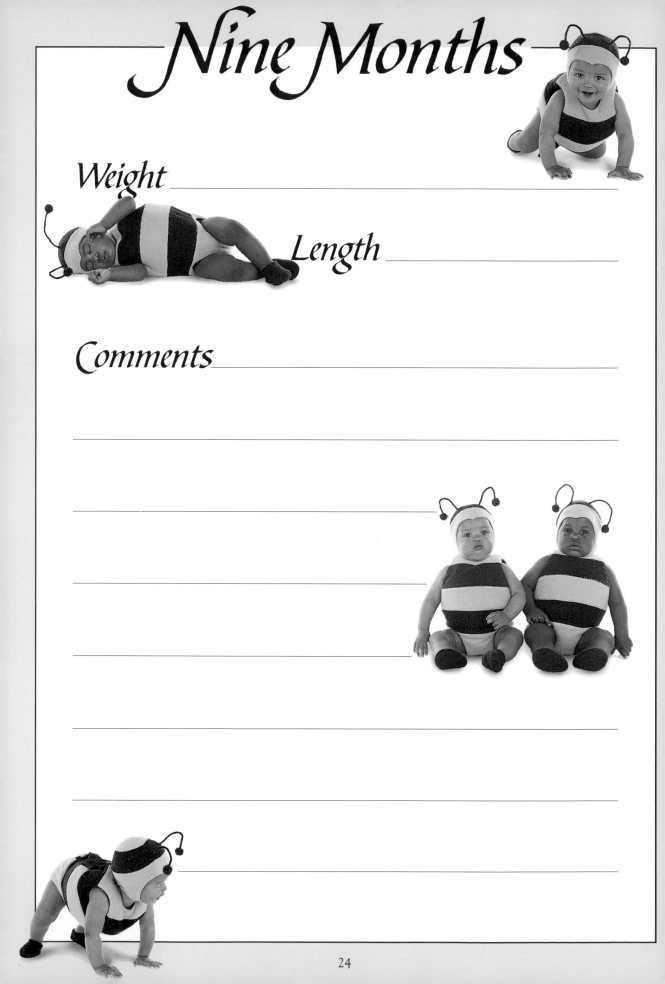

Weight _____

Length _____

Comments _____

Photographs

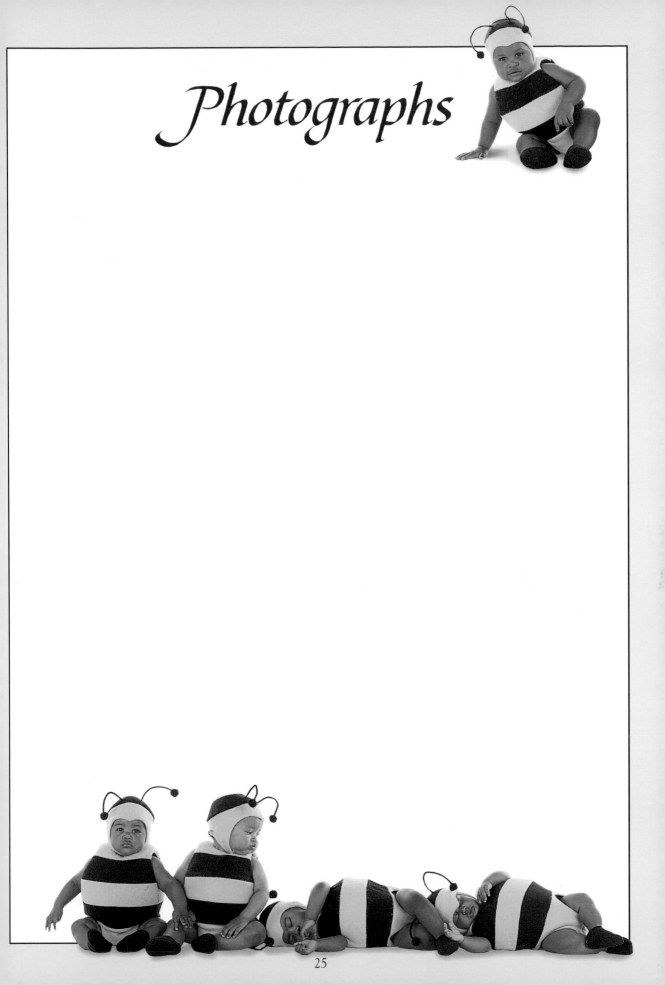

Milestones

I first smiled _____

laughed _____

grasped a toy _____

I slept through the night

I held my head up _____

rolled over _____

sat up _____

Comments _____

*I first crawled*_____

*stood up*_____*walked* _____

*My first tooth*_____

My first word

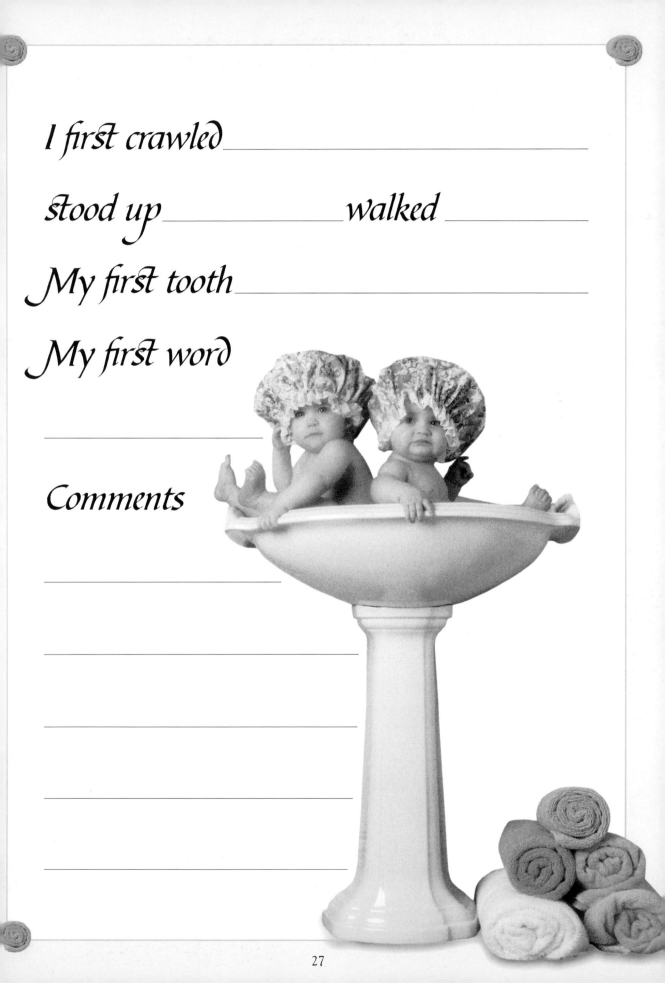

Comments

Food

My first solid food _____

I was weaned _____

I drank from a cup _____

Finger food _____

I fed myself _____

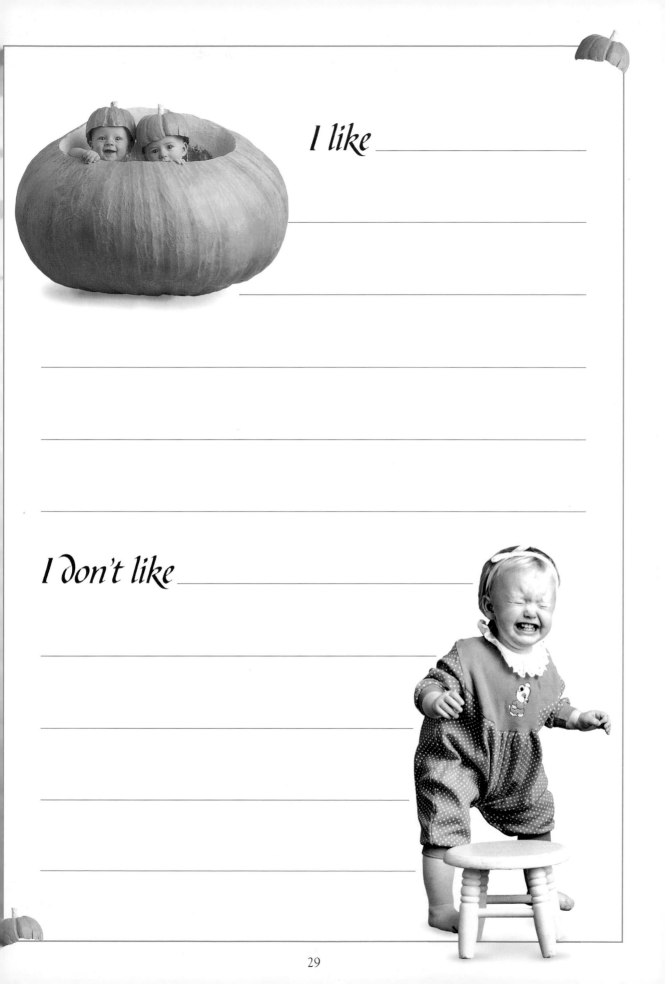

I like _____

I don't like _____

My First Christmas

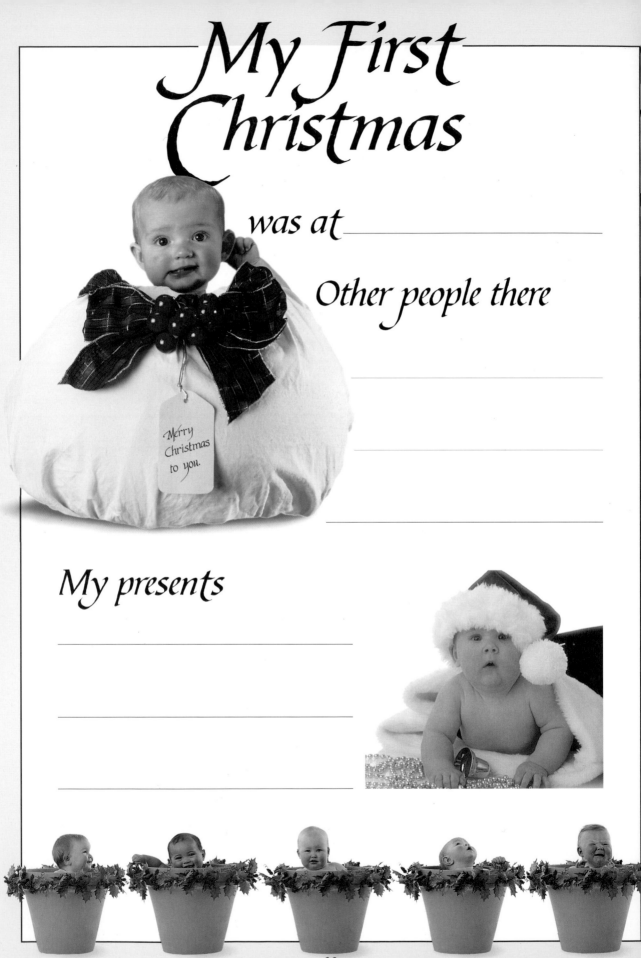

was at _____

Other people there

My presents

Photographs

My First Vacation

Was at _____

Date _____

The weather was _____

Other people there _____

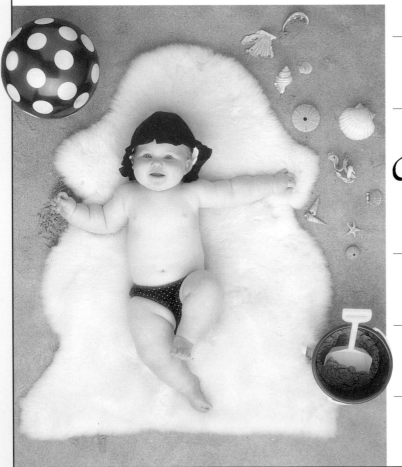

Comments

Photographs

My First Birthday

I live at _____

My height is_____

Weight _____

Sayings _____

Toys_____

Pets _____

Books_____

My Party

Date _____

Where held _____

Friends and relations there _____

My presents _____

Photographs

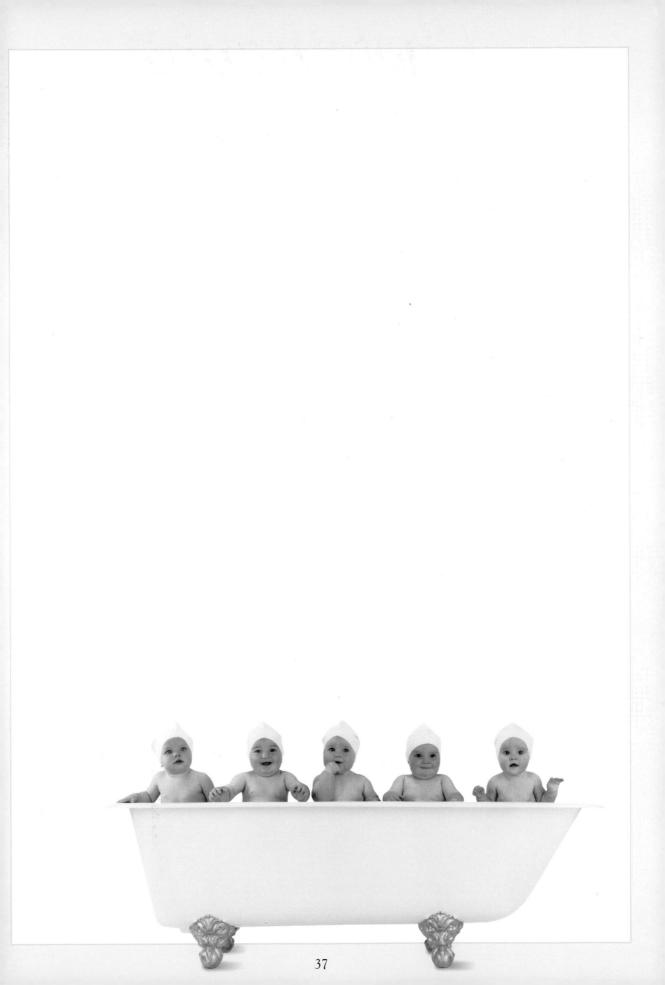

Clothes

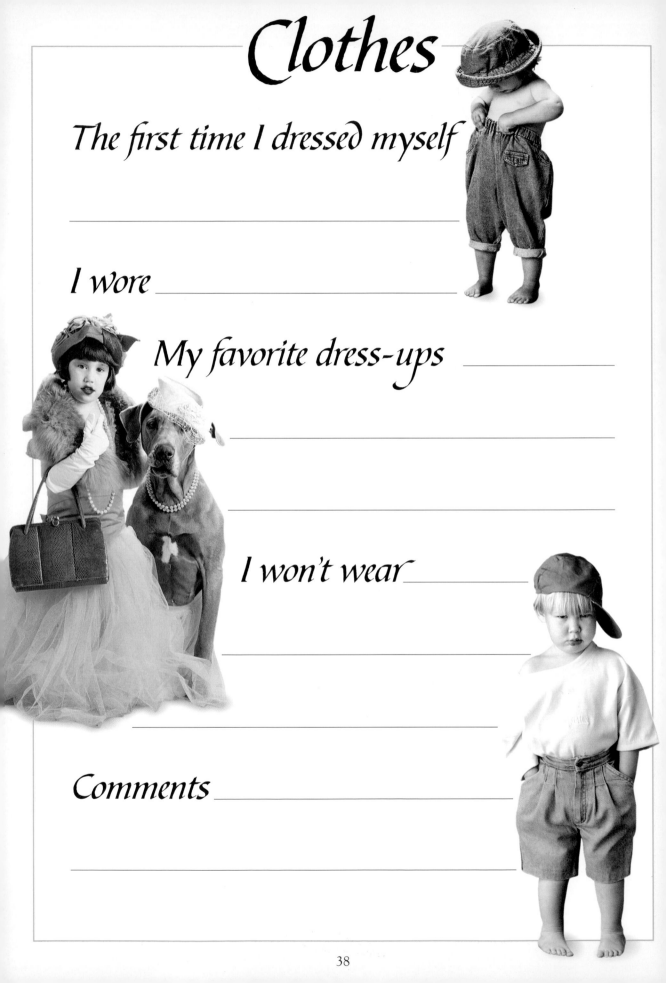

The first time I dressed myself

I wore _____

My favorite dress-ups _____

I won't wear_____

Comments _____

Photographs

Favorites

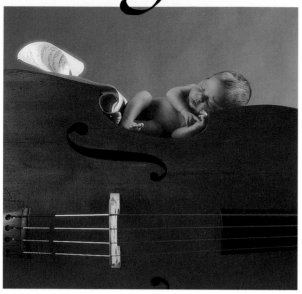

Music _____

Rhymes _____

Clothes _____

Animals _____

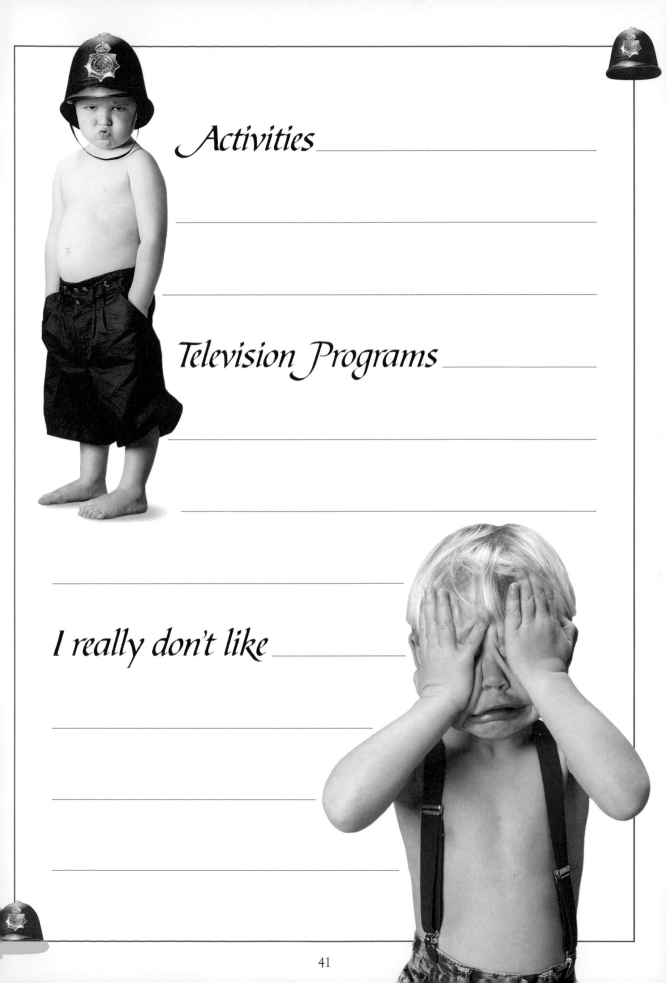

Activities _____

Television Programs _____

I really don't like _____

Best Friends

One Year

photo

Two Years

photo

Comments _____

Three Years

photo

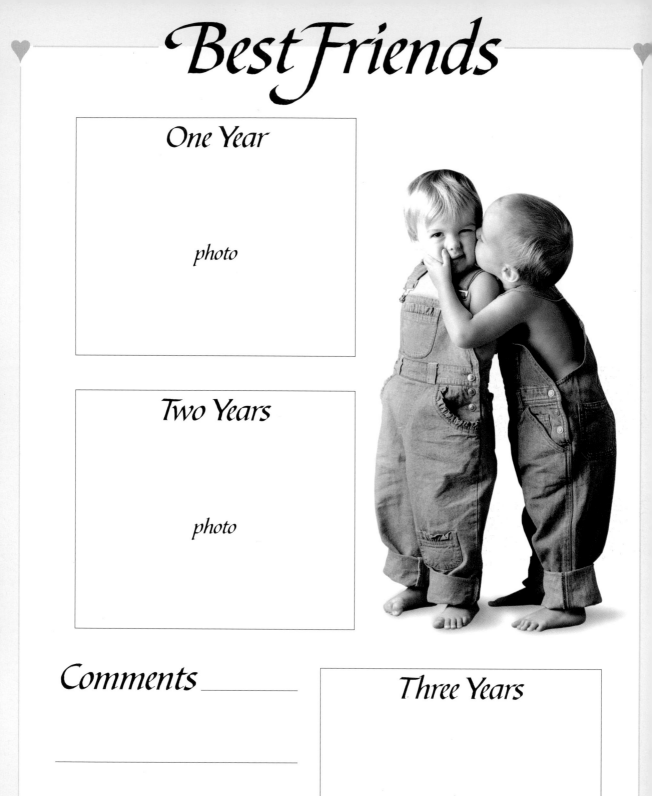

Comments _____

Four Years

photo

Five Years

photo

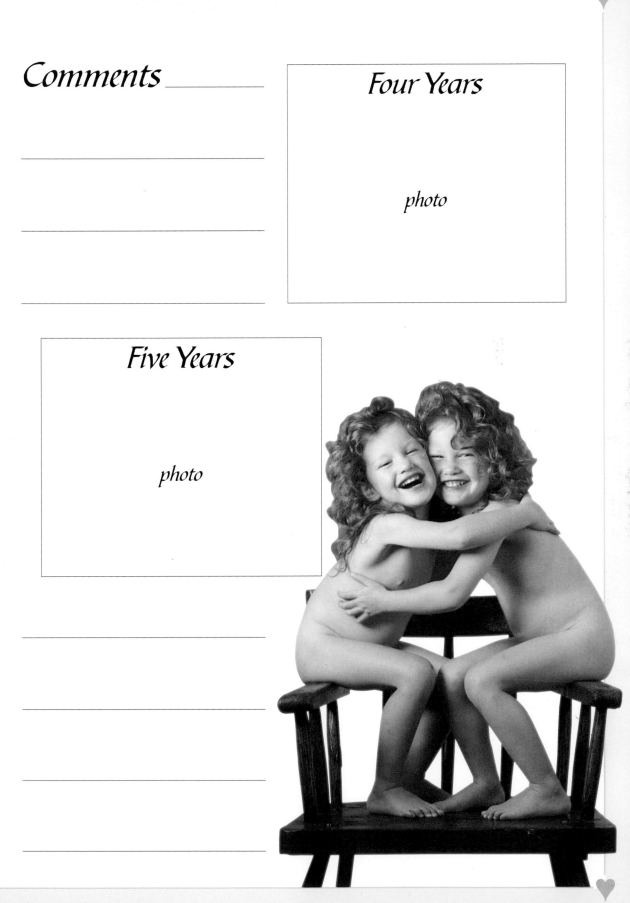

My Second Birthday

I live at _____

My height is _____ Weight _____

Sayings _____

Toys _____

Pets _____

Books _____

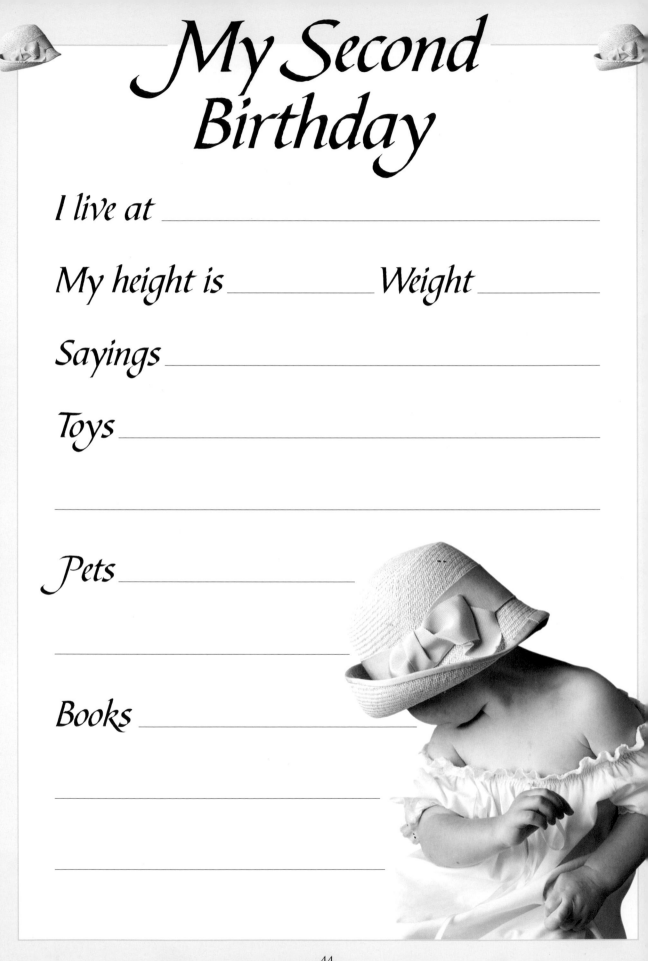

My Party

Date _____

Where held _____

Friends and relations there

My presents _____

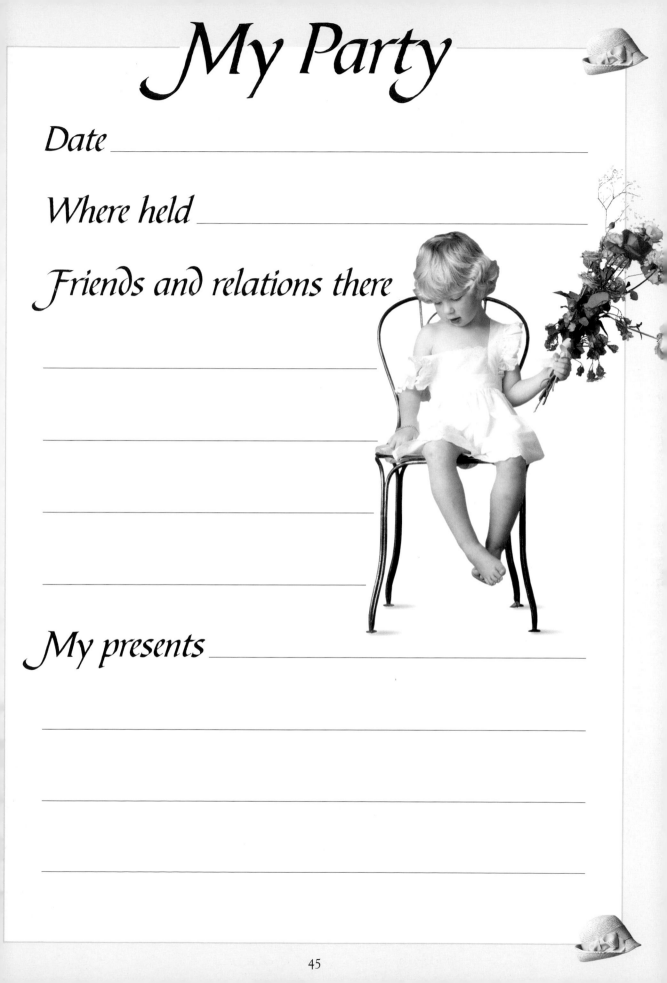

Photographs

My Third Birthday

I live at _____

My height is _____ Weight _____

Sayings _____

Toys _____

Pets _____

Books _____

My Party

Date _____

Where held _____

Friends and relations there _____

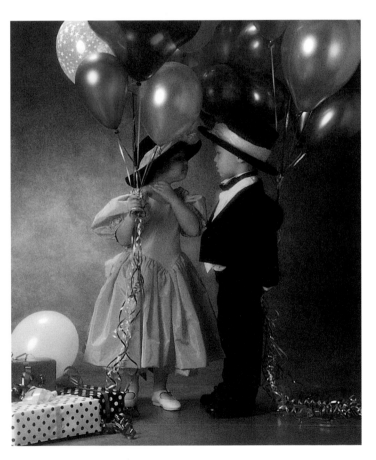

My presents

Photographs

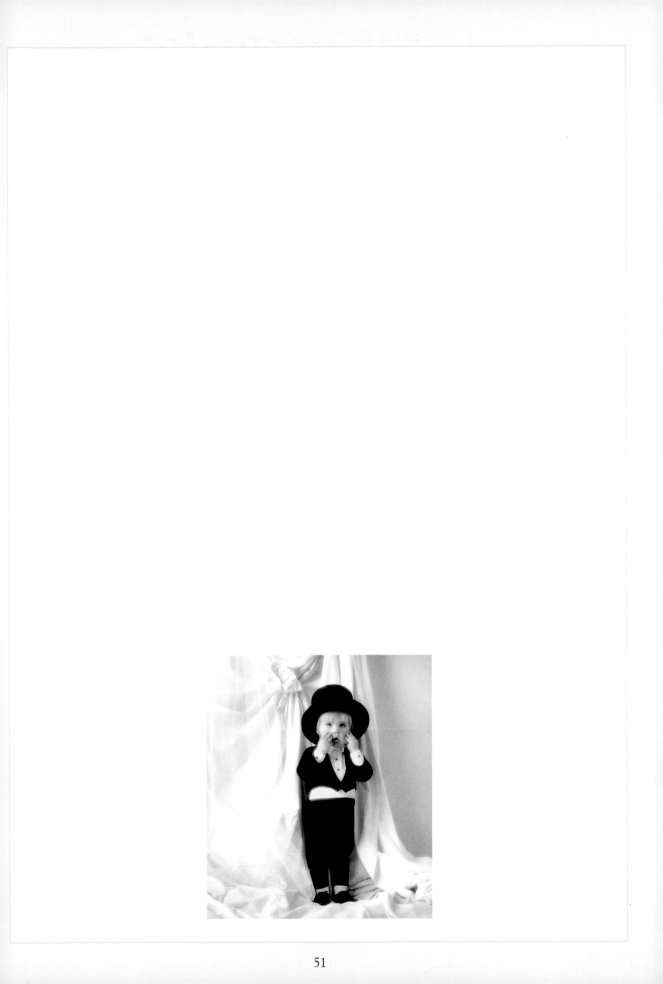

My Fourth Birthday

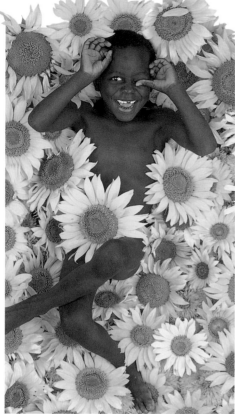

I live at _____

My height is _____

Weight _____

Sayings _____

Toys _____

Pets _____

Books _____

My Party

Date_____

Where held _____

Friends and relations there _____

My presents_____

Photographs

Pre-School

My first day at pre-school was on _____

_____ *at* _____

My teacher is _____

Comments _____

Photographs

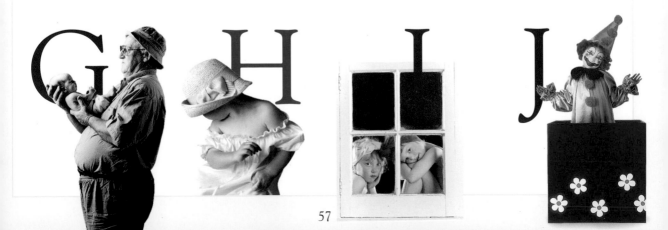

My Fifth Birthday

I live at _____

My height is _____ Weight _____

Sayings _____

Toys _____

Pets _____

Books _____

My Party

Date _____

Where held _____

Friends and relations there

My presents _____

Photographs

Kindergarten

I started on _____

at _____

My friends are _____

Comments _____

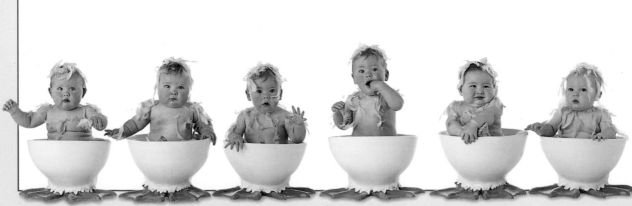

62

Photographs

Drawings

Oh no!

P

Q

R

Writing

I could recite the alphabet _____

I started to write _____

I began to read _____

My writing _____

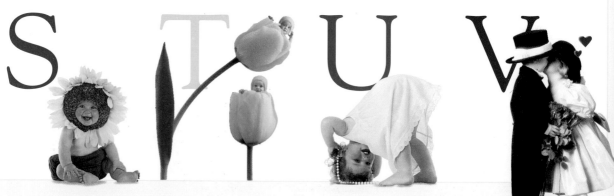

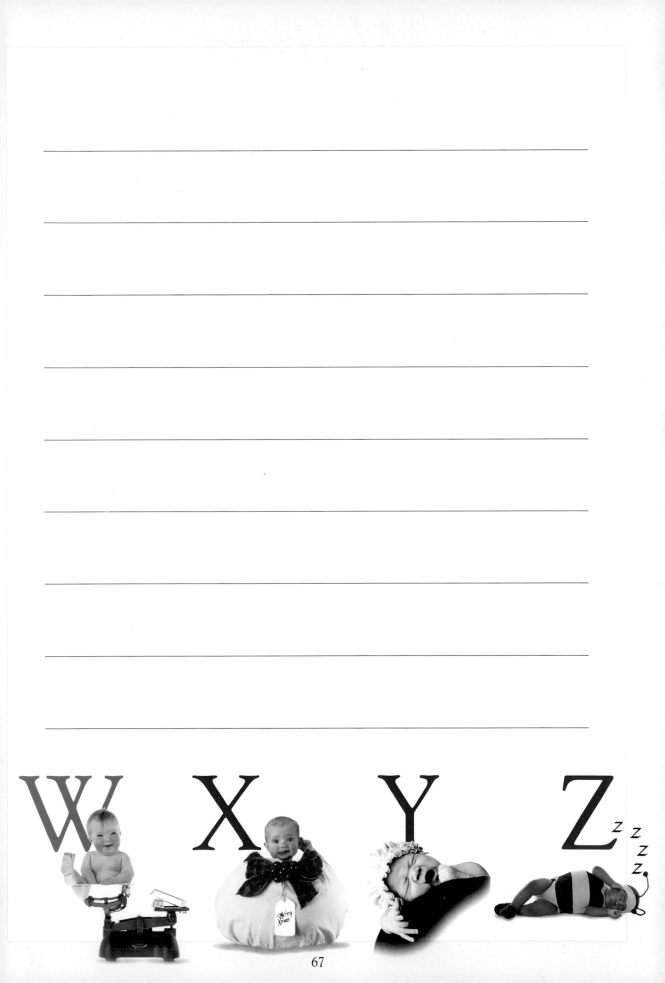

W X Y Z

Health

Immunization

Age	Vaccine	Date given

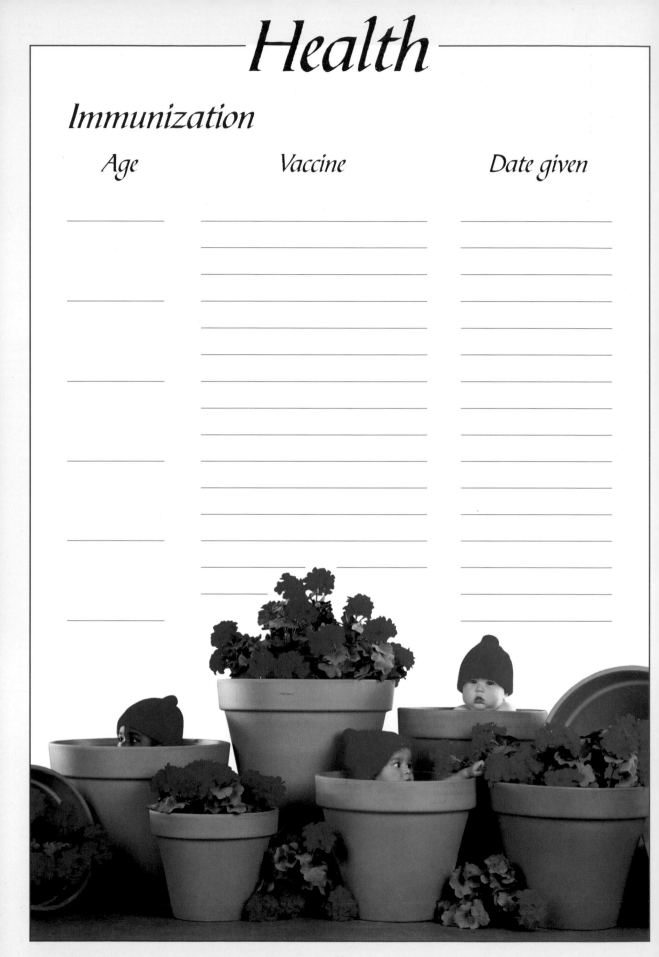

Allergies

Illnesses _____

Comments _____

My Height

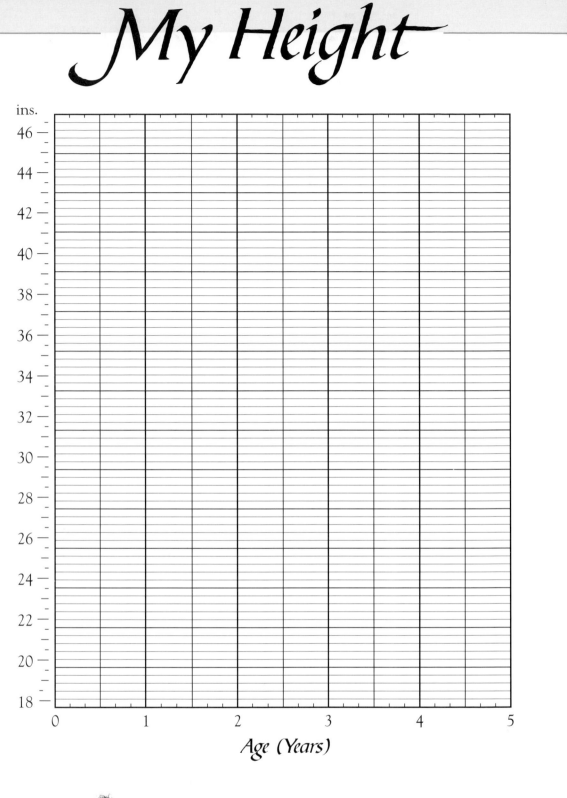

Age (Years)

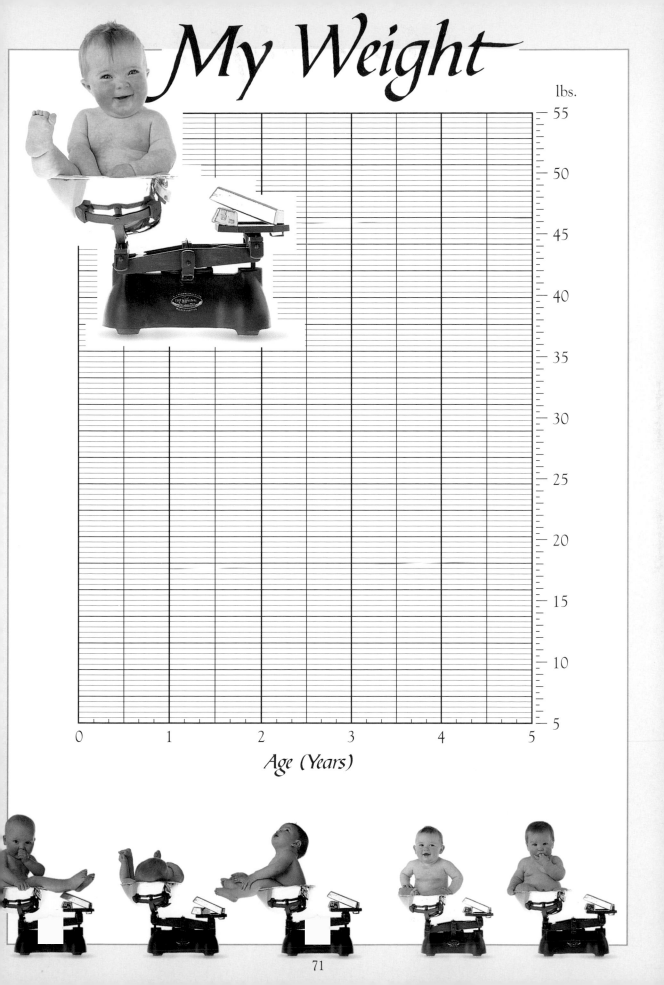

My Weight

lbs.
55
50
45
40
35
30
25
20
15
10
5

Age (Years)

0 1 2 3 4 5

My Teeth

Upper Jaw

Date

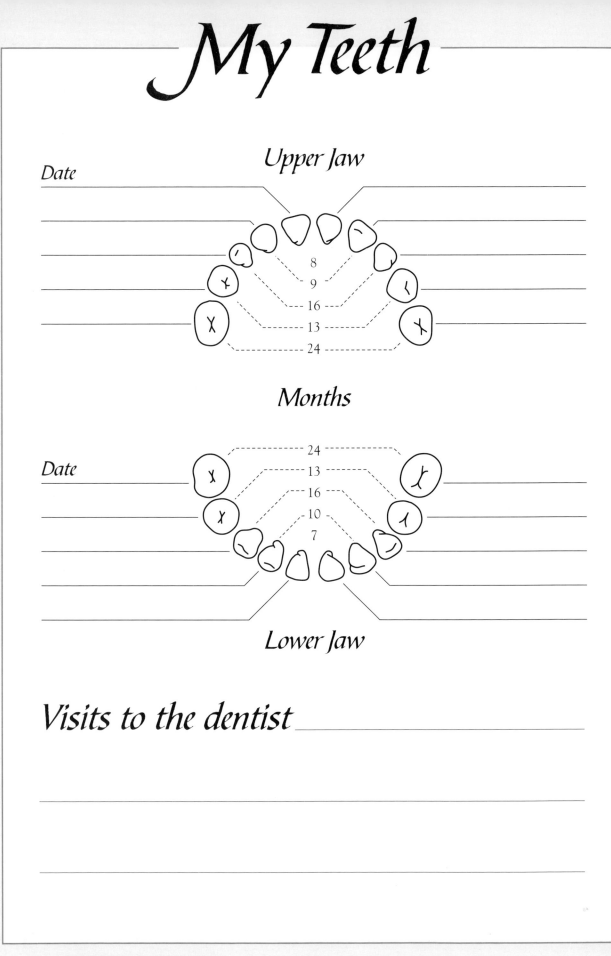

8
9
16
13
24

Months

24
13
16
10
7

Date

Lower Jaw

Visits to the dentist

The Tooth Fairy's page

I lost my first tooth on _____

My second tooth _____

The Tooth Fairy left me _____

Comments _____

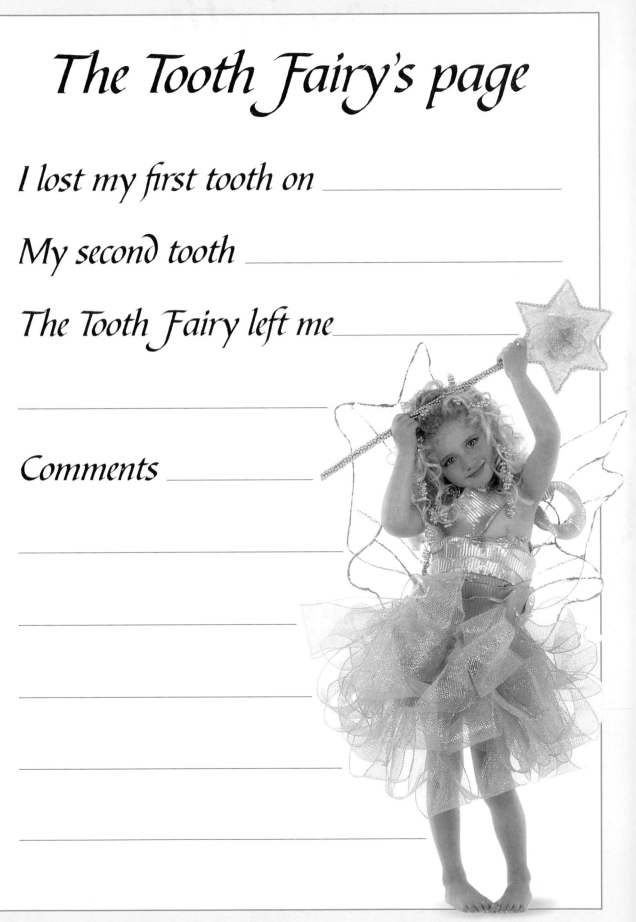

My Handprints

At birth

At five years

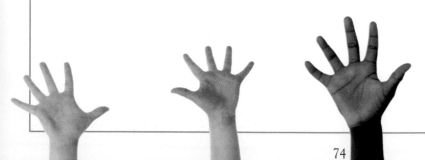

My Footprints

At birth

At five years

Star Signs

Capricorn

22 December – 20 January
Resourceful, self-sufficient, responsible

Aquarius

21 January – 18 February
Great caring for others, very emotional
under cool exterior

Pisces

19 February – 19 March
Imaginative, sympathetic, tolerant

Aries

20 March – 20 April
Brave, courageous, energetic, loyal

Taurus

21 April – 21 May
Sensible, love peace and stability

Gemini

22 May – 21 June
Unpredictable, lively, charming, witty

Cancer

22 June – 22 July
Love security, comfort

Leo

23 July – 23 August
Idealistic, romantic, honorable, loyal

Virgo

24 August – 23 September
Shy, sensitive, value knowledge

Libra

24 September – 23 October
Diplomat, full of charm and style

Scorpio

24 October – 22 November
Compassionate, proud, determined

Sagittarius

23 November – 21 December
Bold, impulsive, seek adventure

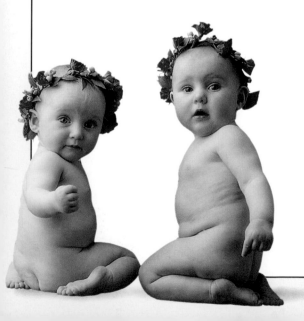

Birth Stones

January	Garnet – Constancy and truth
February	Amethyst – Sincerity, humility
March	Aquamarine – Courage and energy
April	Diamond – Innocence, success
May	Emerald – Tranquillity
June	Pearl – Precious, pristine
July	Ruby – Carefree, chaste
August	Moonstone – Joy
September	Sapphire – Hope, chastity
October	Opal – Reflects every mood
November	Topaz – Fidelity, loyalty
December	Turquoise – Love and success

Flowers

January	Snowdrop – Pure and gentle
February	Carnation – Bold and brave
March	Violet – Modest
April	Lily – Virtuous
May	Hawthorn – Bright and hopeful
June	Rose – Beautiful
July	Daisy – Wide-eyed and innocent
August	Poppy – Peaceful
September	Morning Glory – Easily contented
October	Cosmos – Ambitious
November	Chrysanthemum – Sassy and cheerful
December	Holly – Full of foresight

Comments

Photographs

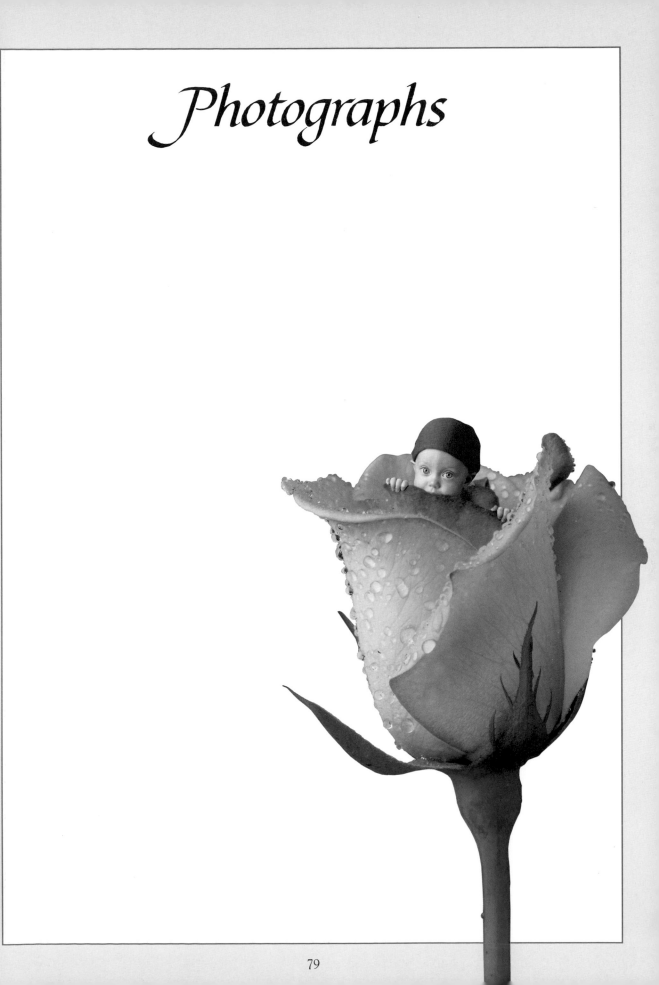

Comments

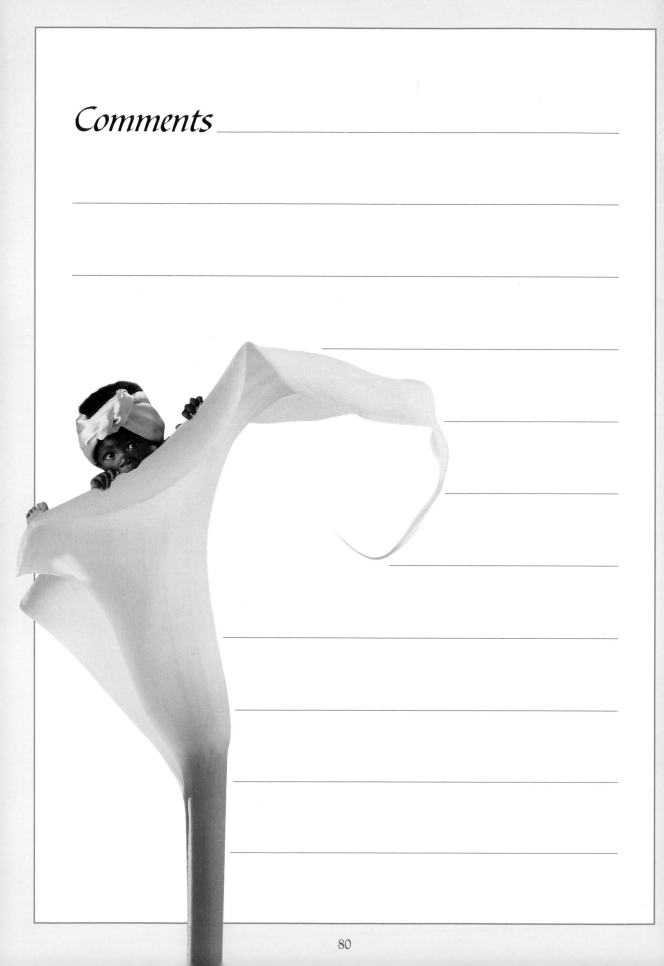

Photographs